20 intricate and original illustrations by

D S BLAKE

FIRST EDITION 2016
Copyright © Idle Toil 2016

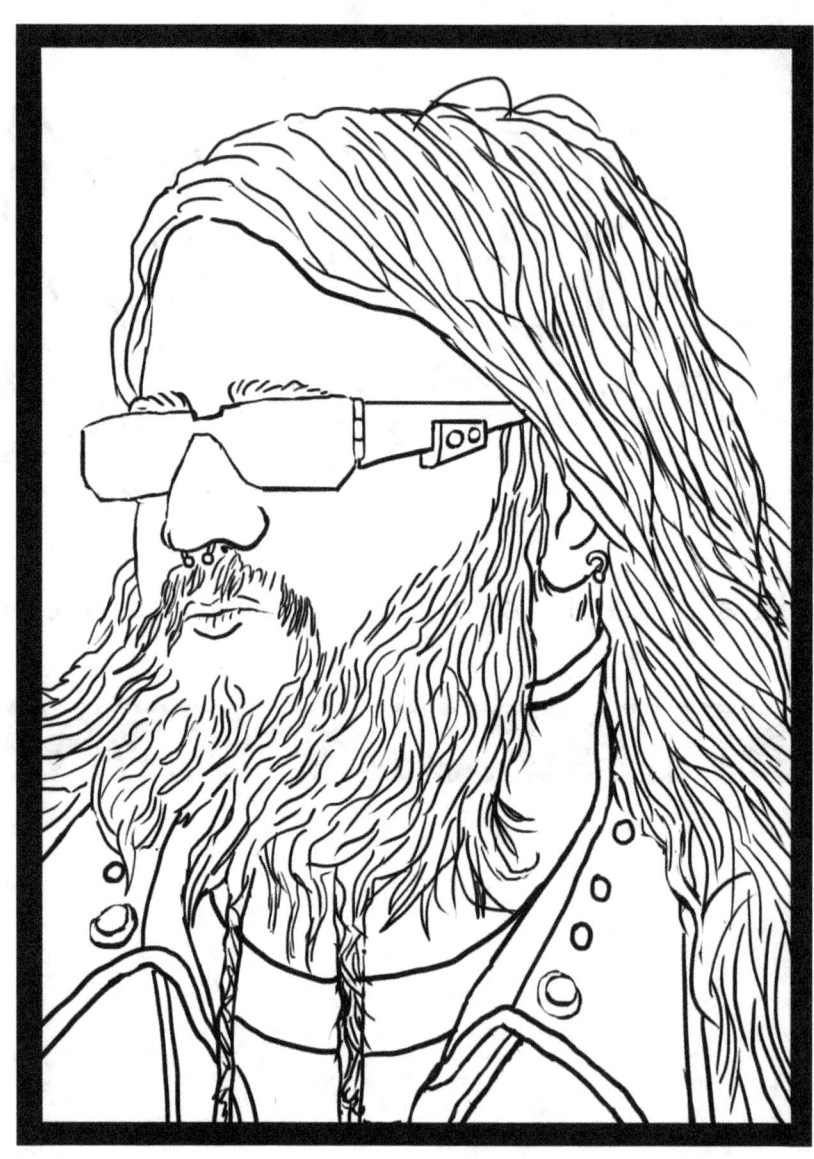

```
With thanks to N
for their support
```

WARNING! This book contains some images of a macabre and/or violent nature and is recommended for adults only

Please Note: Each image has a blank spread seperating it from each other image. This is to allow you to use pens and other colouring media that might bleed through or smudge without having to worry about damaging other images. No pages are missing from this book.

```
Follow on Twitter:
@SimonCardew

DS Blake on deviantart:
DSblake.deviantart.com

Support on Patreon:
patreon.com/IdleToil
```

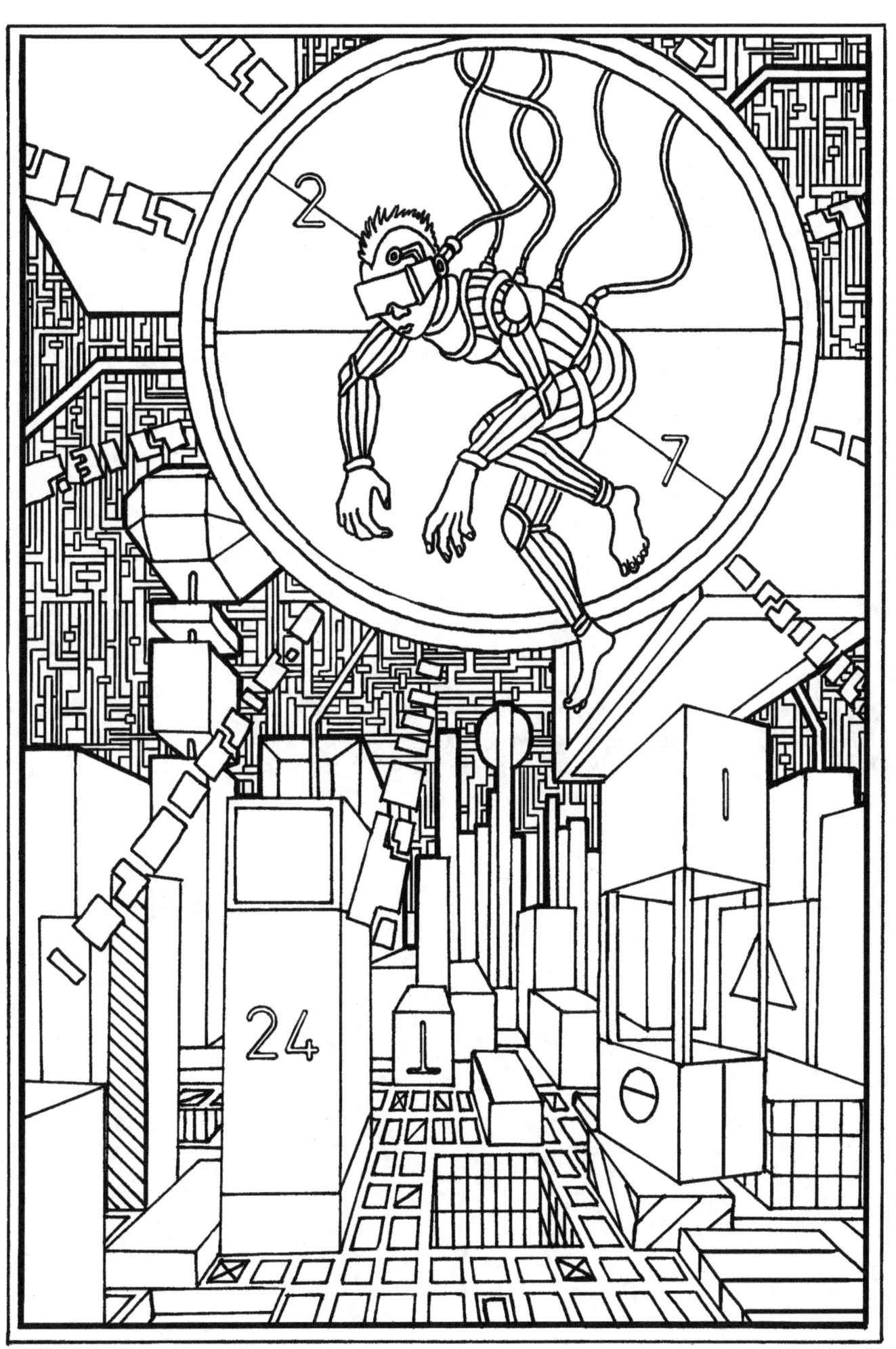

//01. DATA DIVING

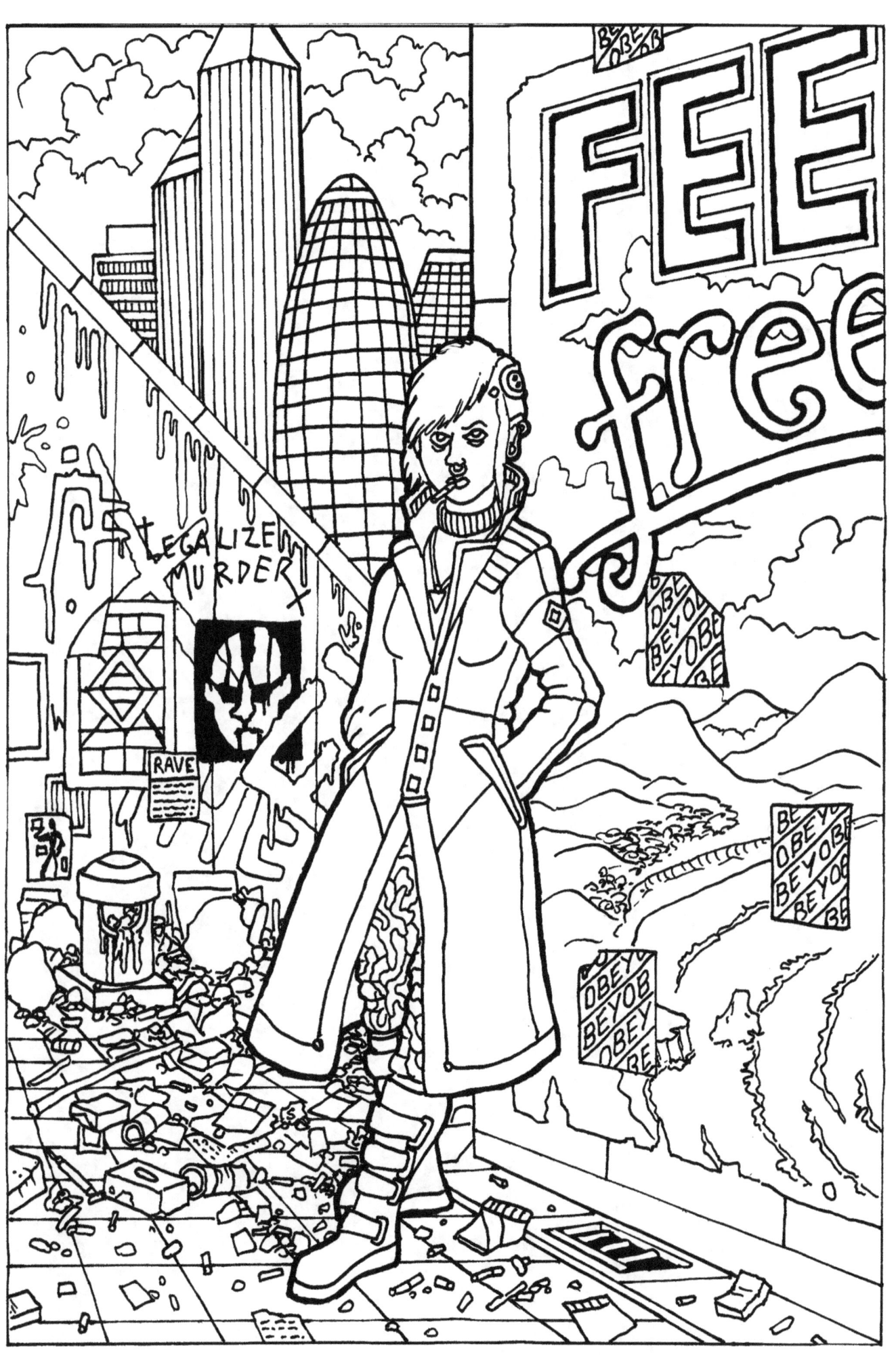

//02. FEEL FREE

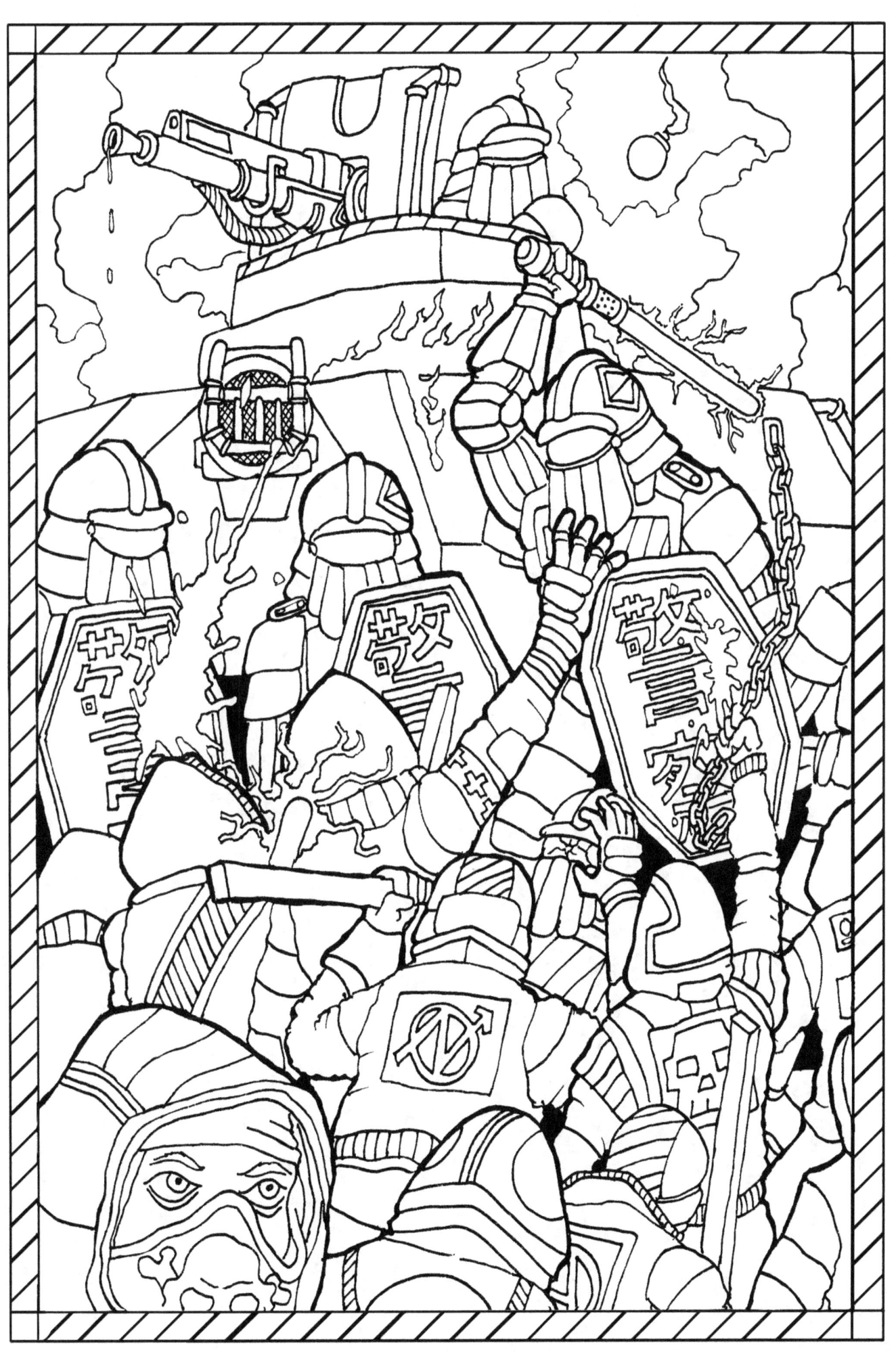

//03. RIOT!

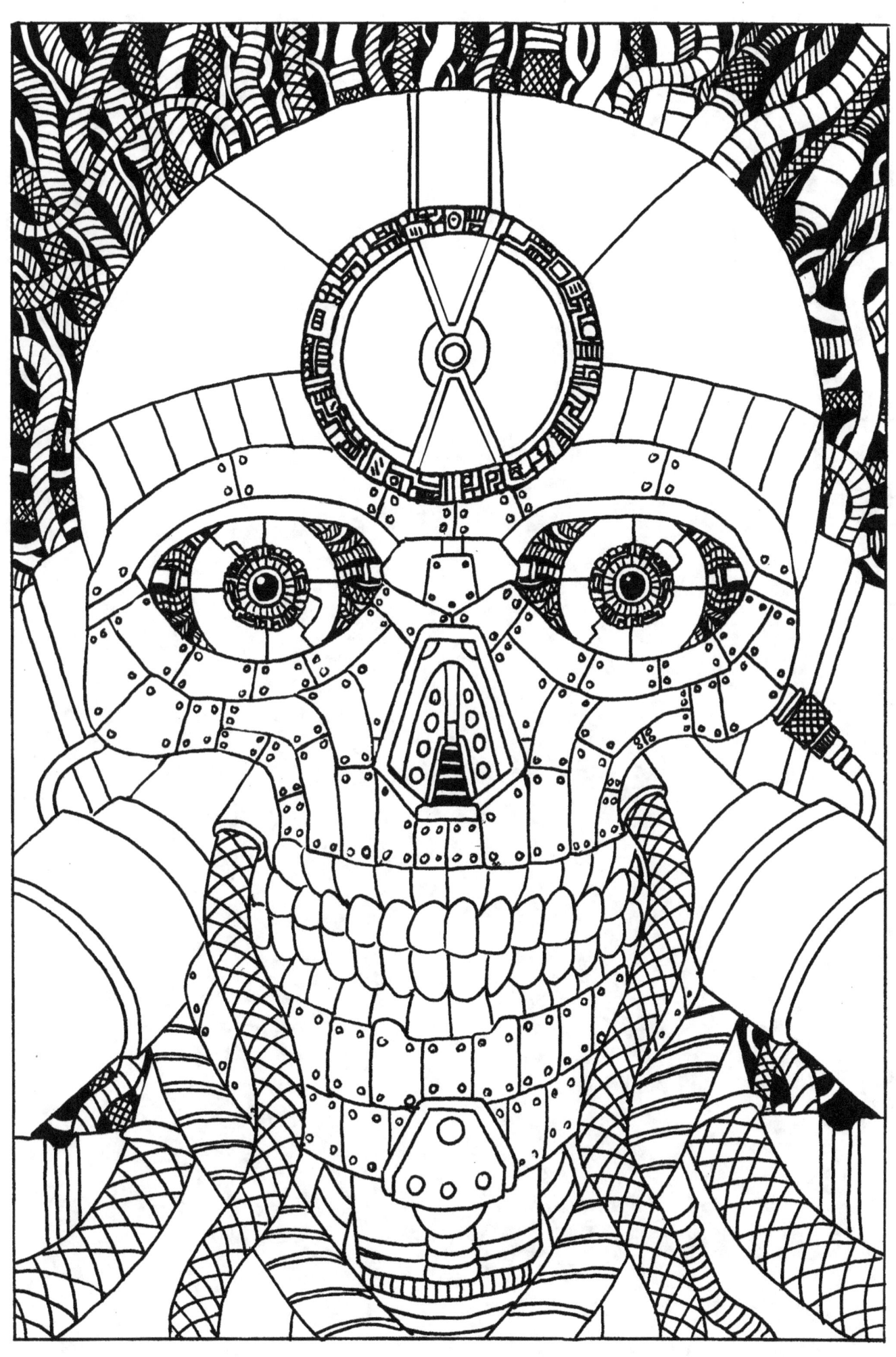

//04. CYBERSKULL

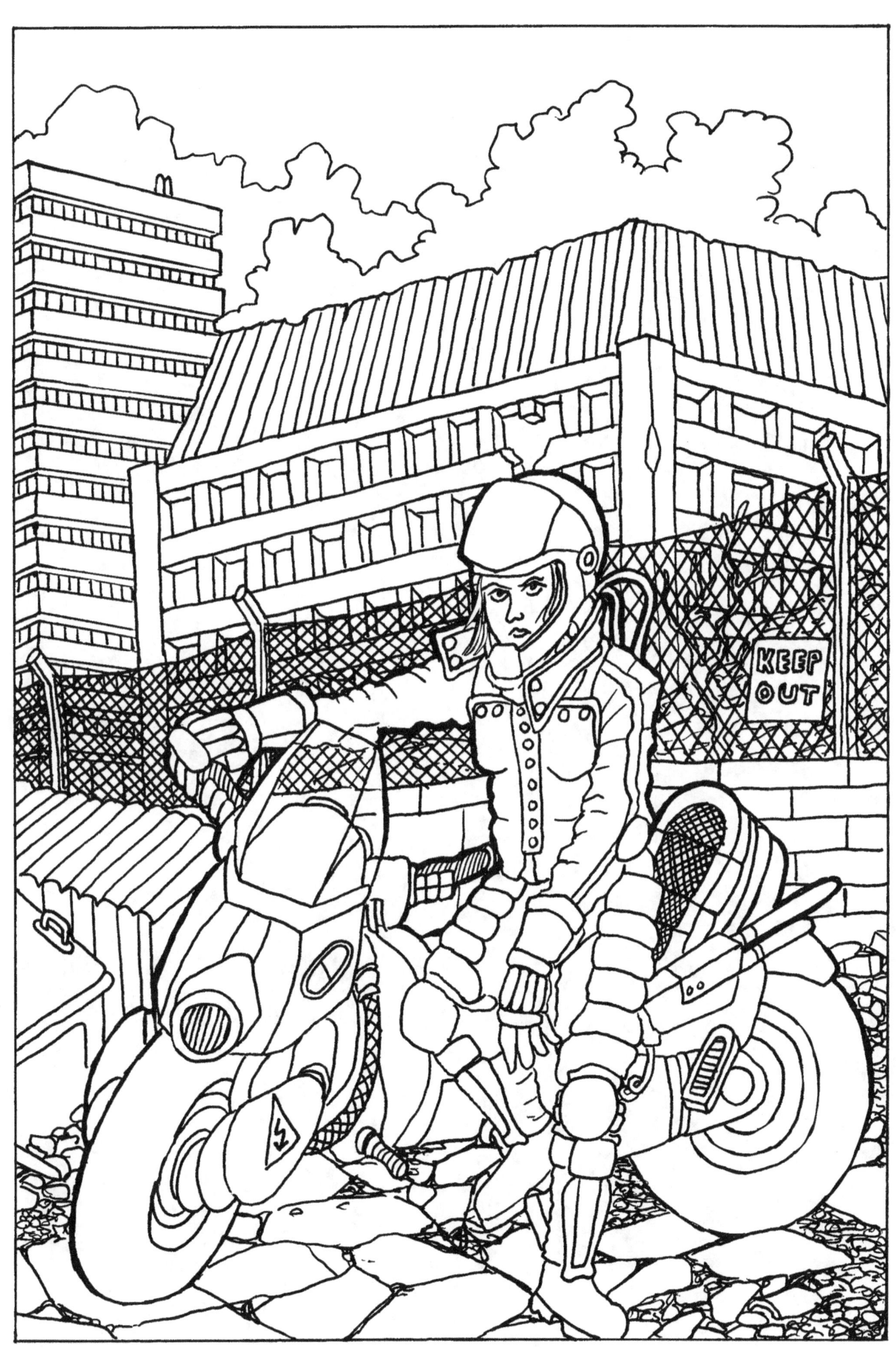

//05. OUTRIDER

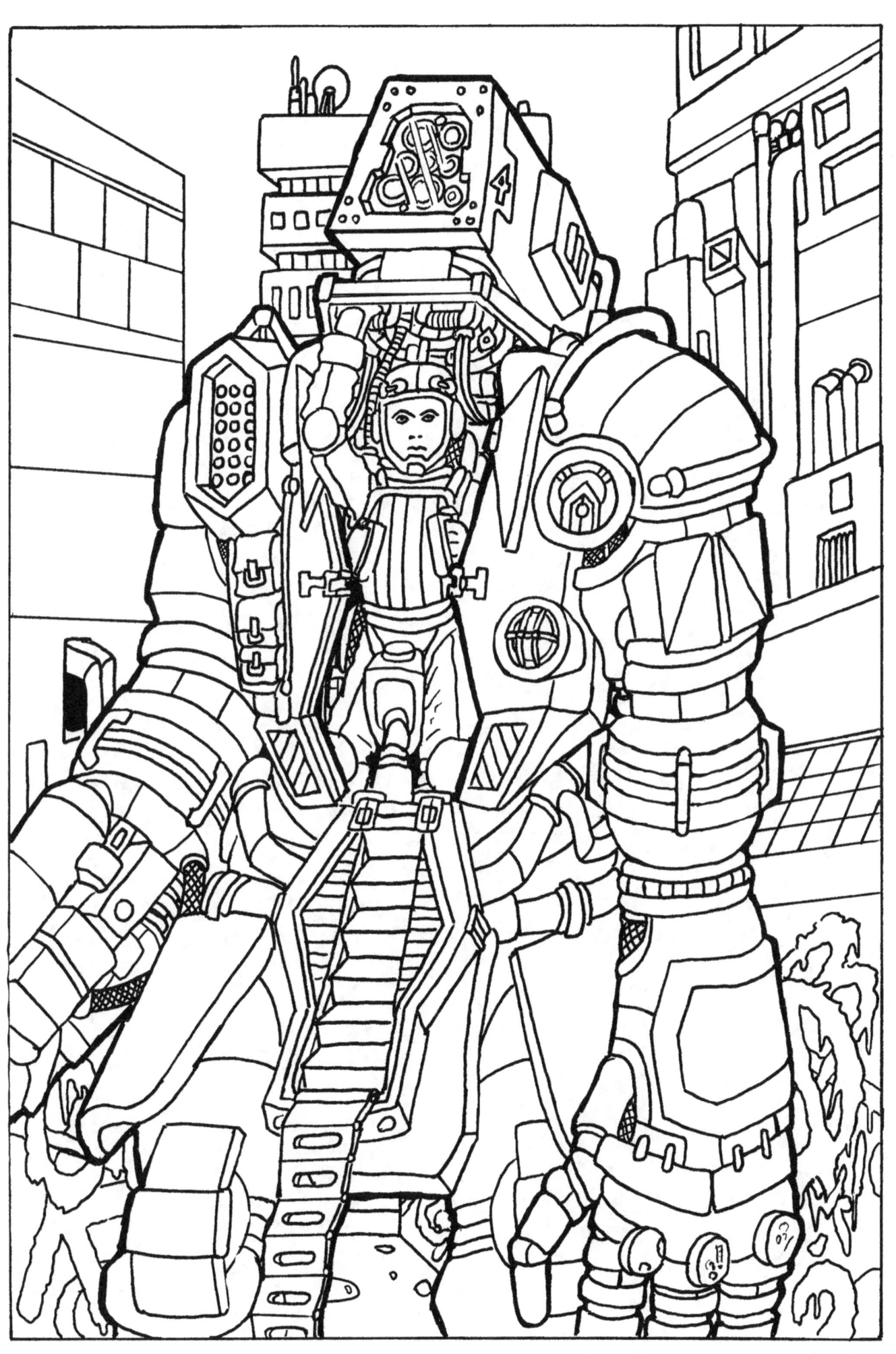

//06. MECHANISED INFANTRY

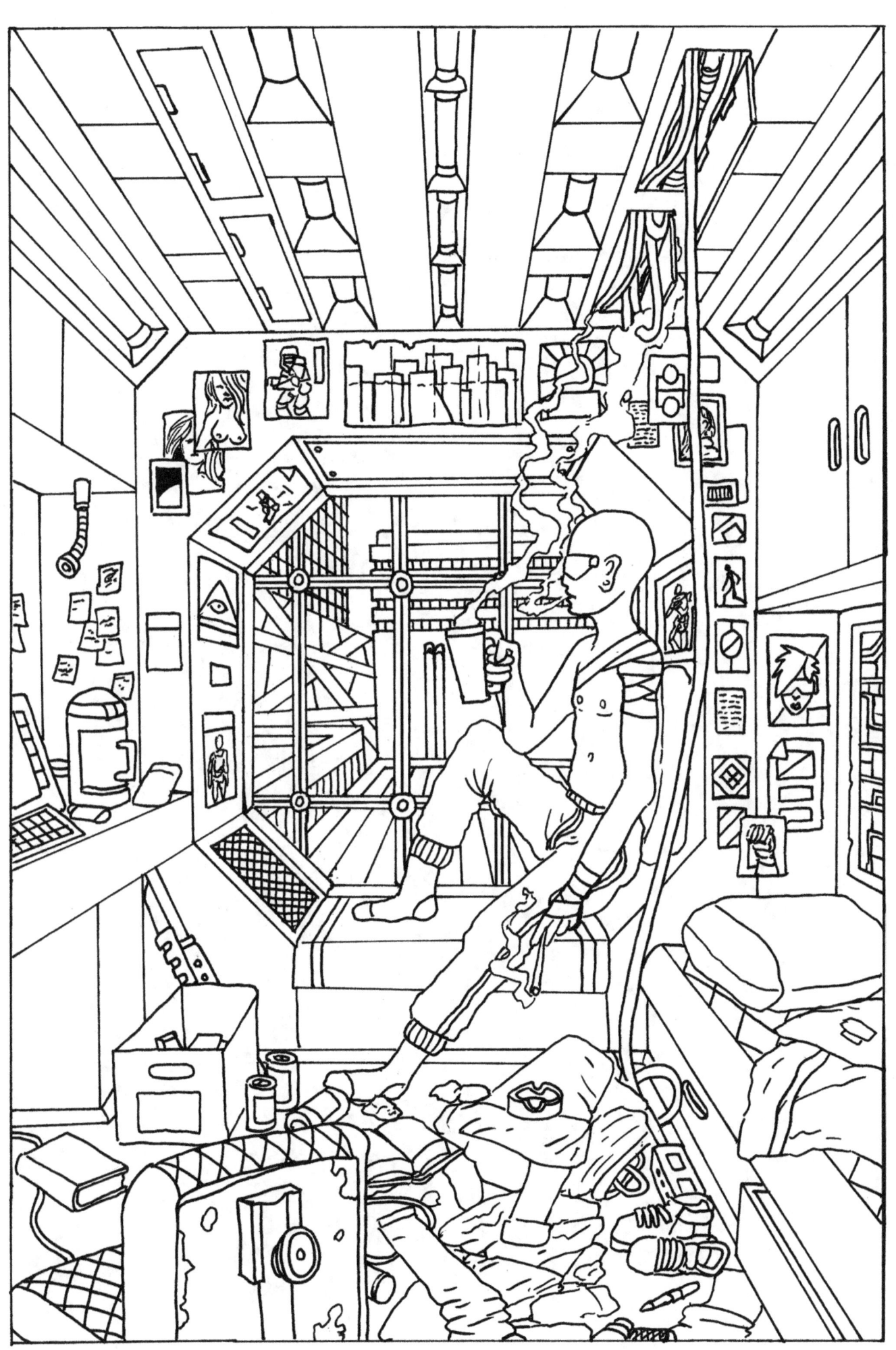

//07. R & R

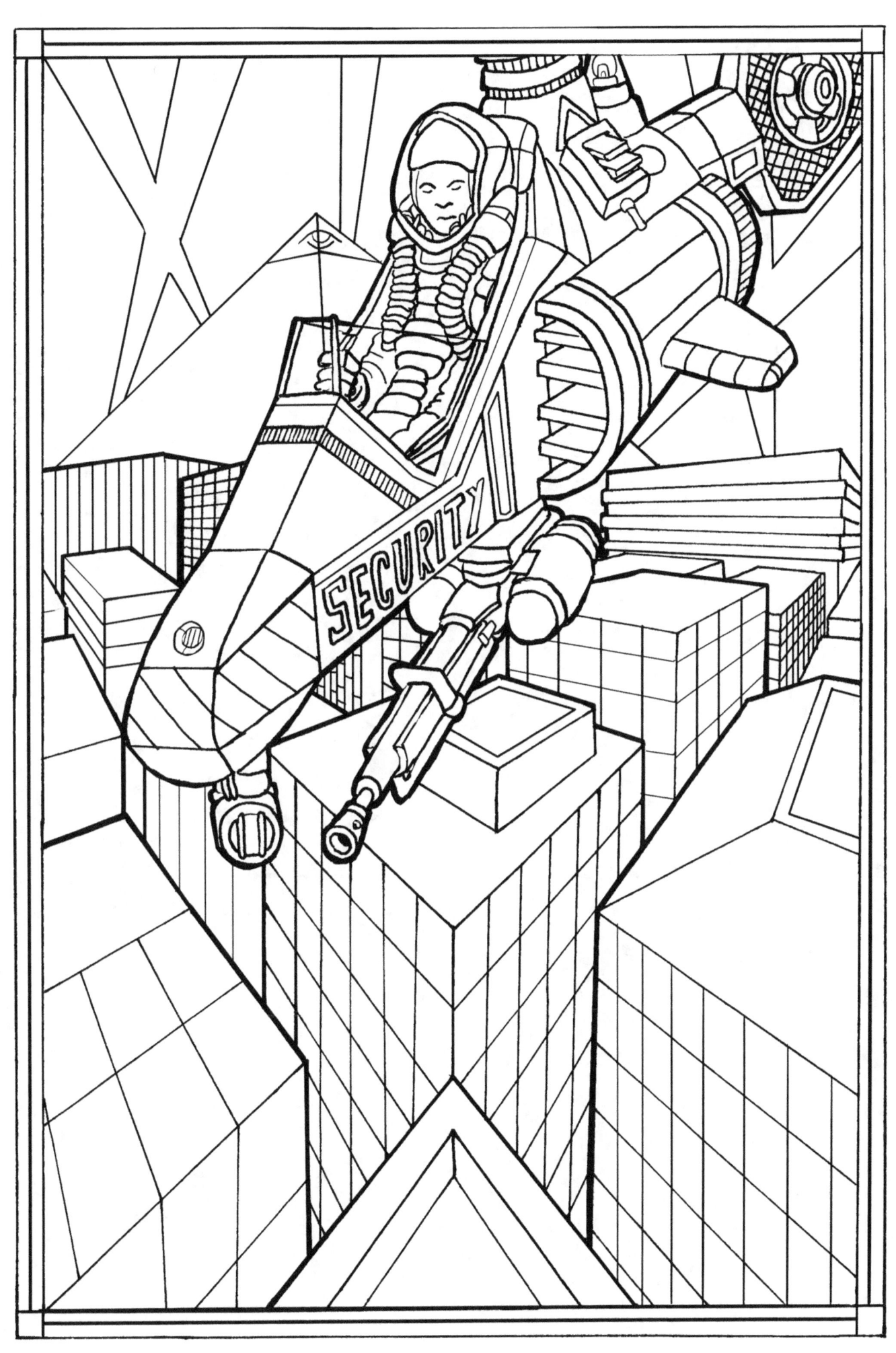

//08. CORPORATE OVERWATCH

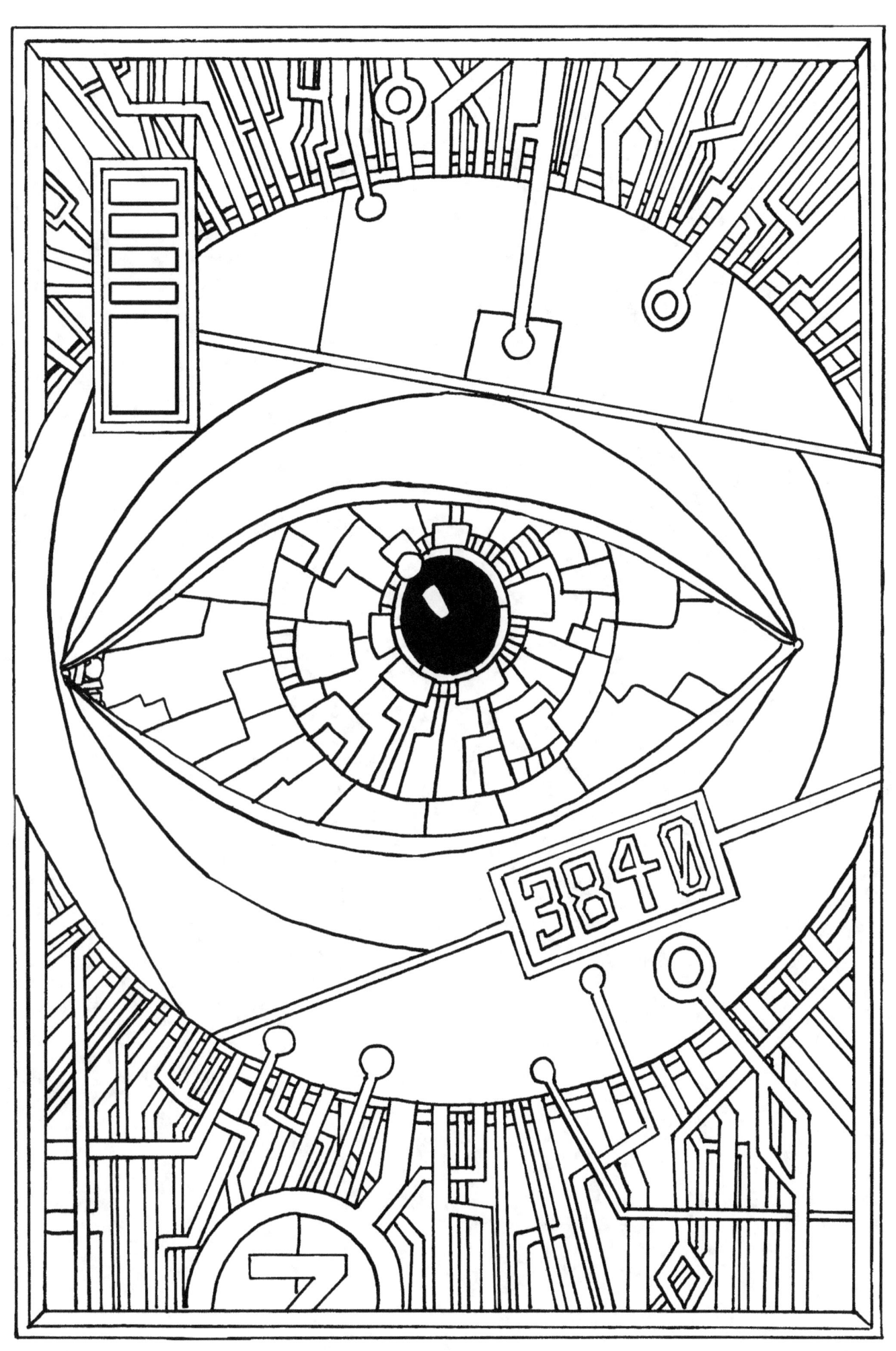

//09. OPTICON

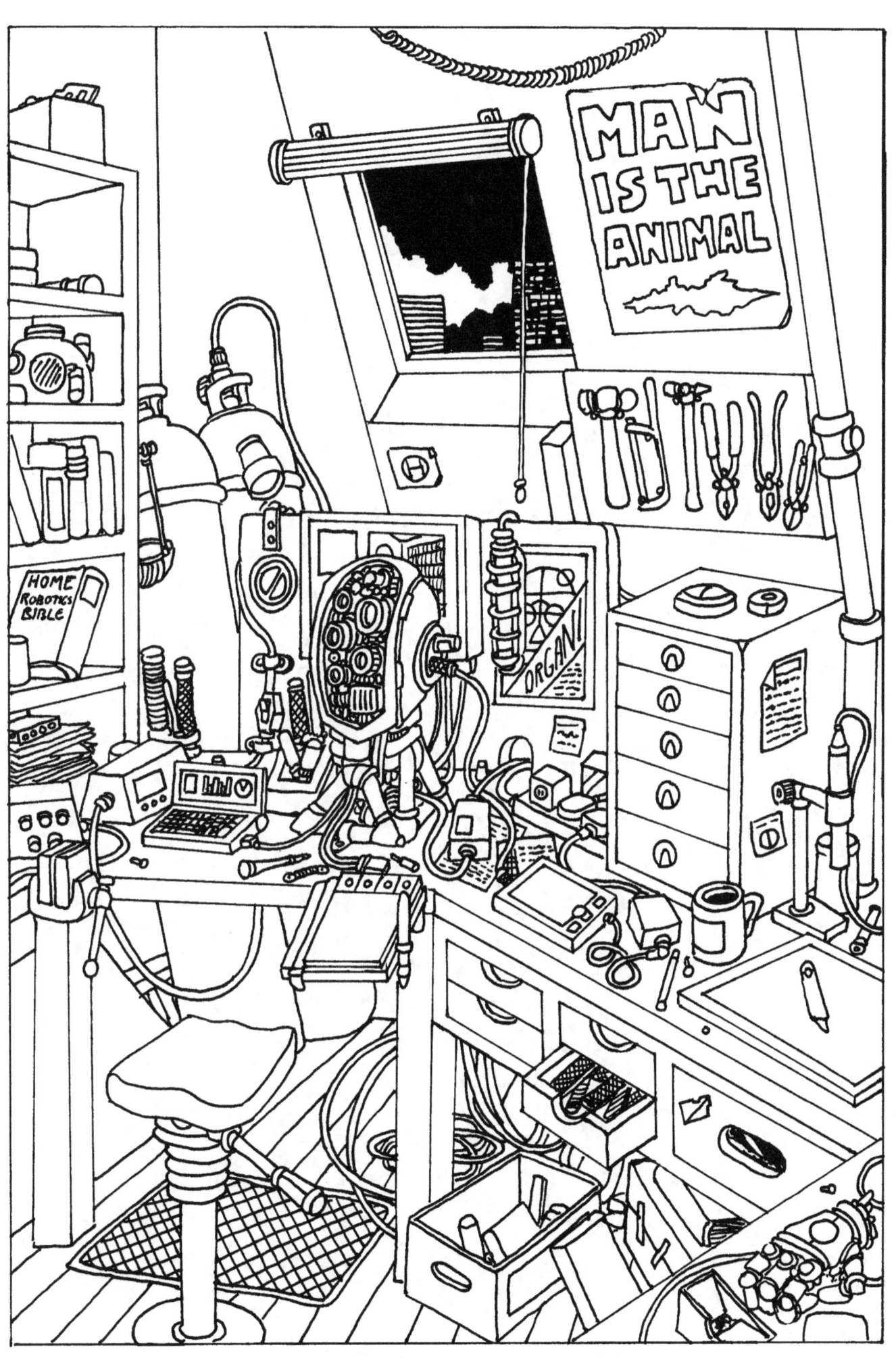

//10. WORKSHOP

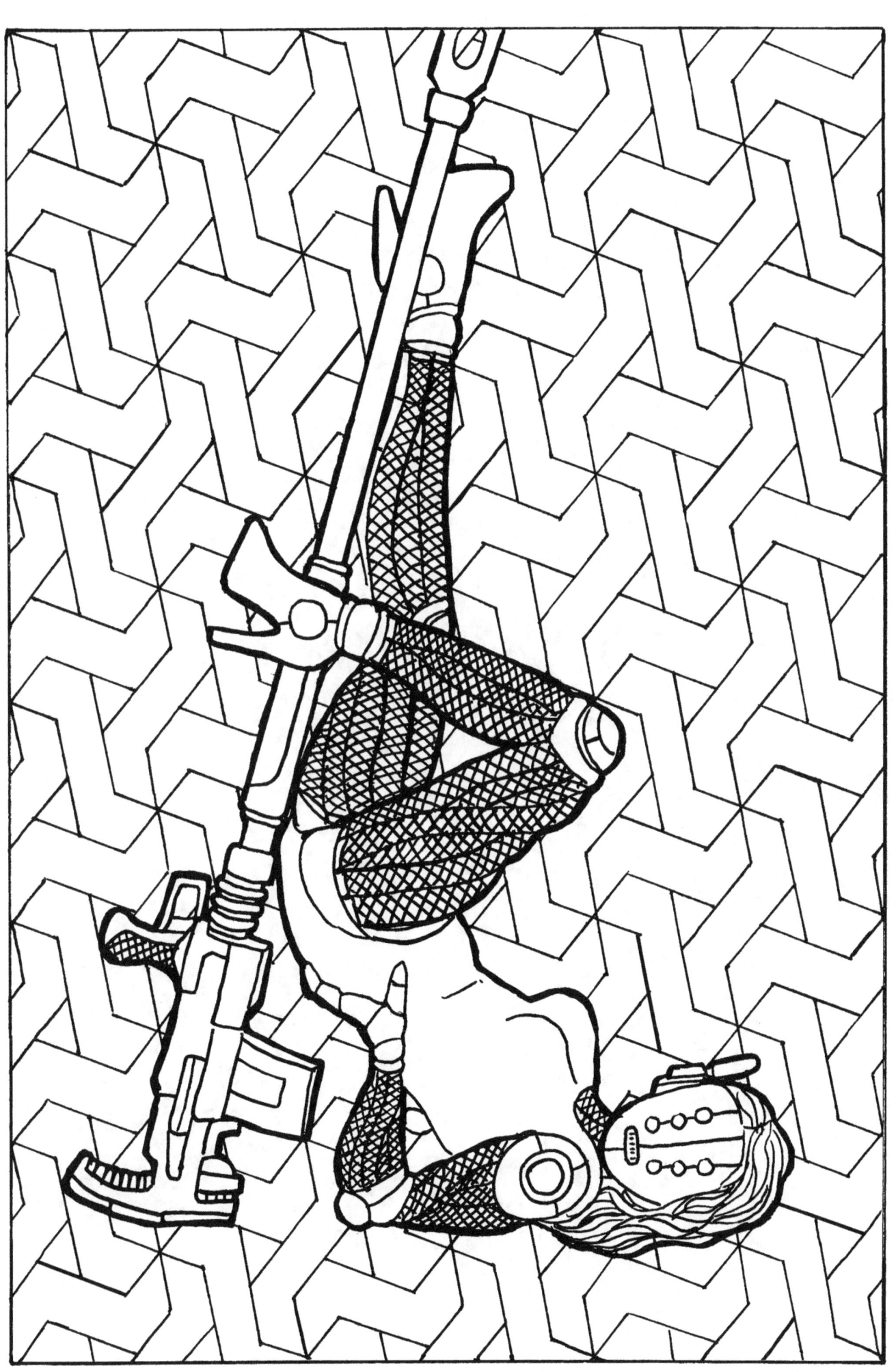

//11. PIN-UP

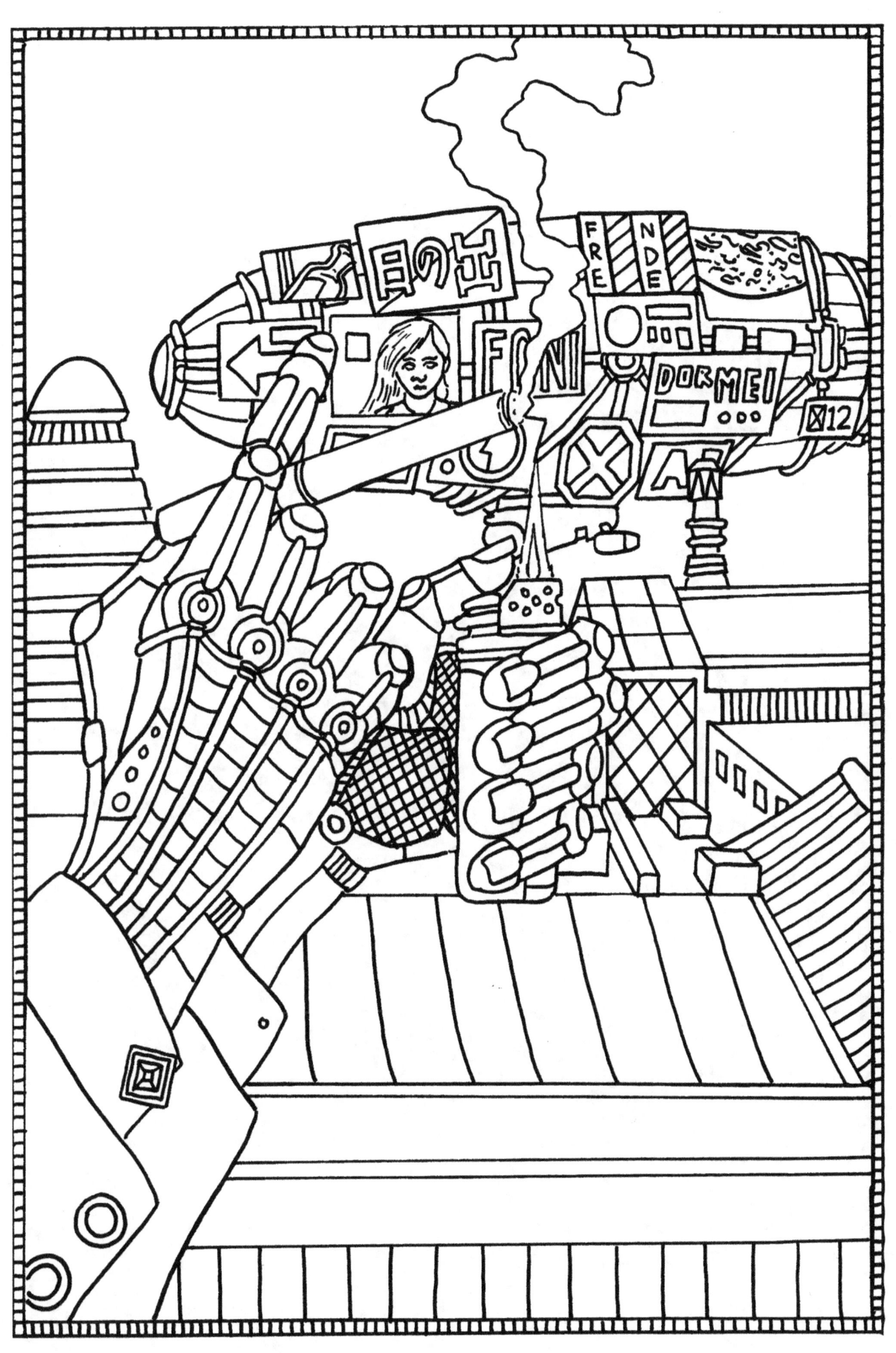

//12. SMOKE BREAK

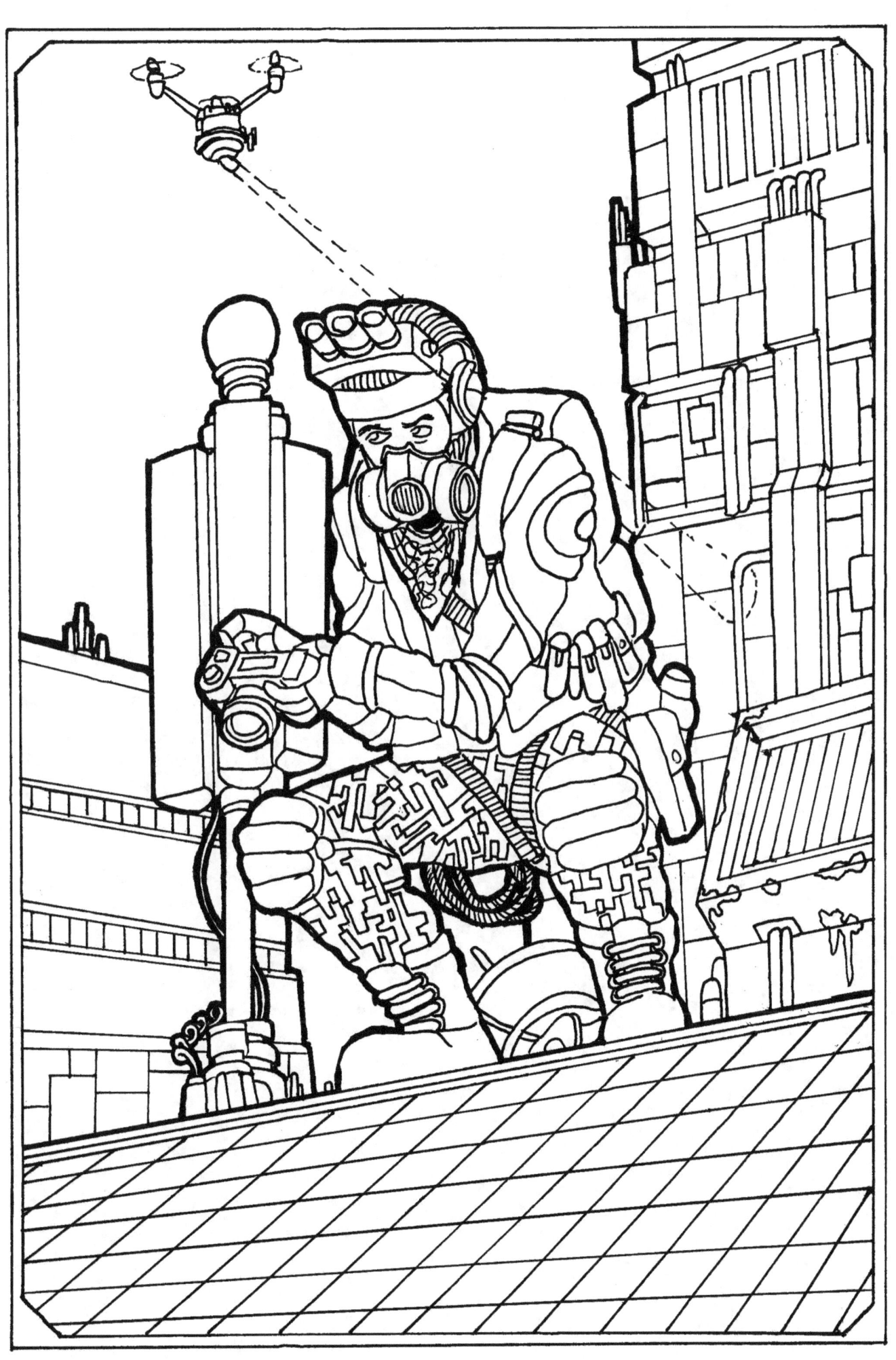

//13. ESPIONAGE

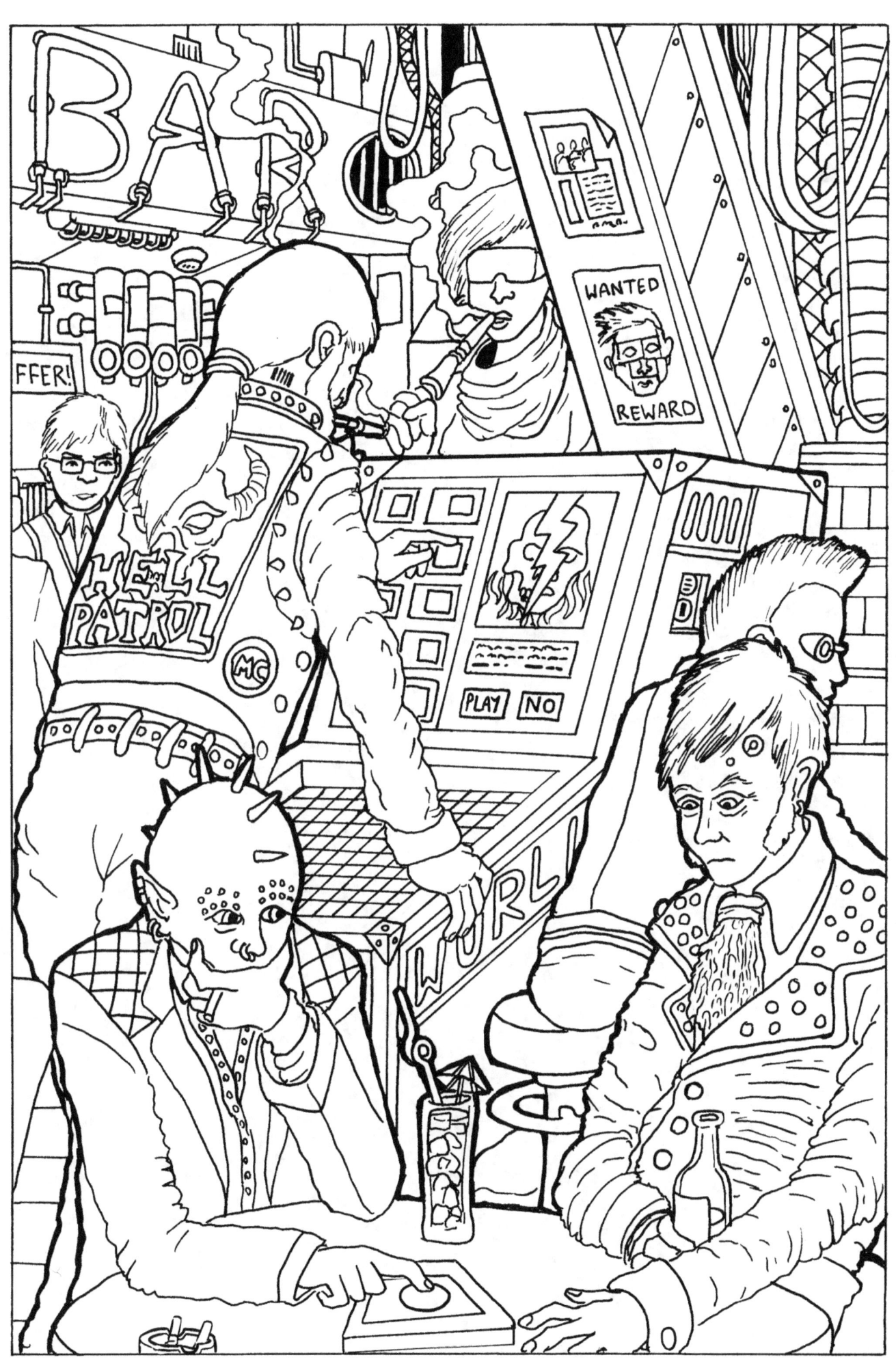

//14. DIVE BAR

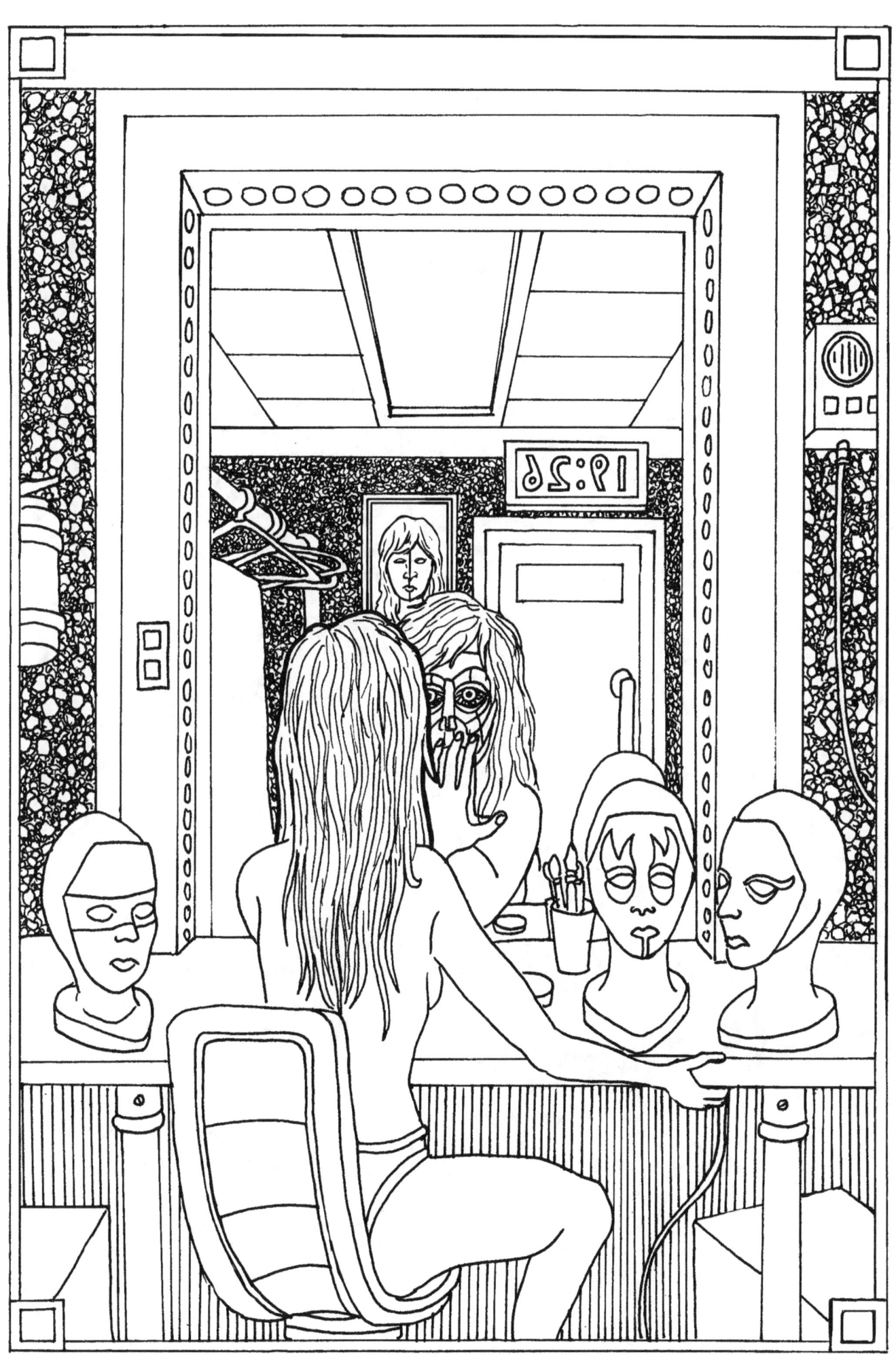

//15. MIRROR STAGE

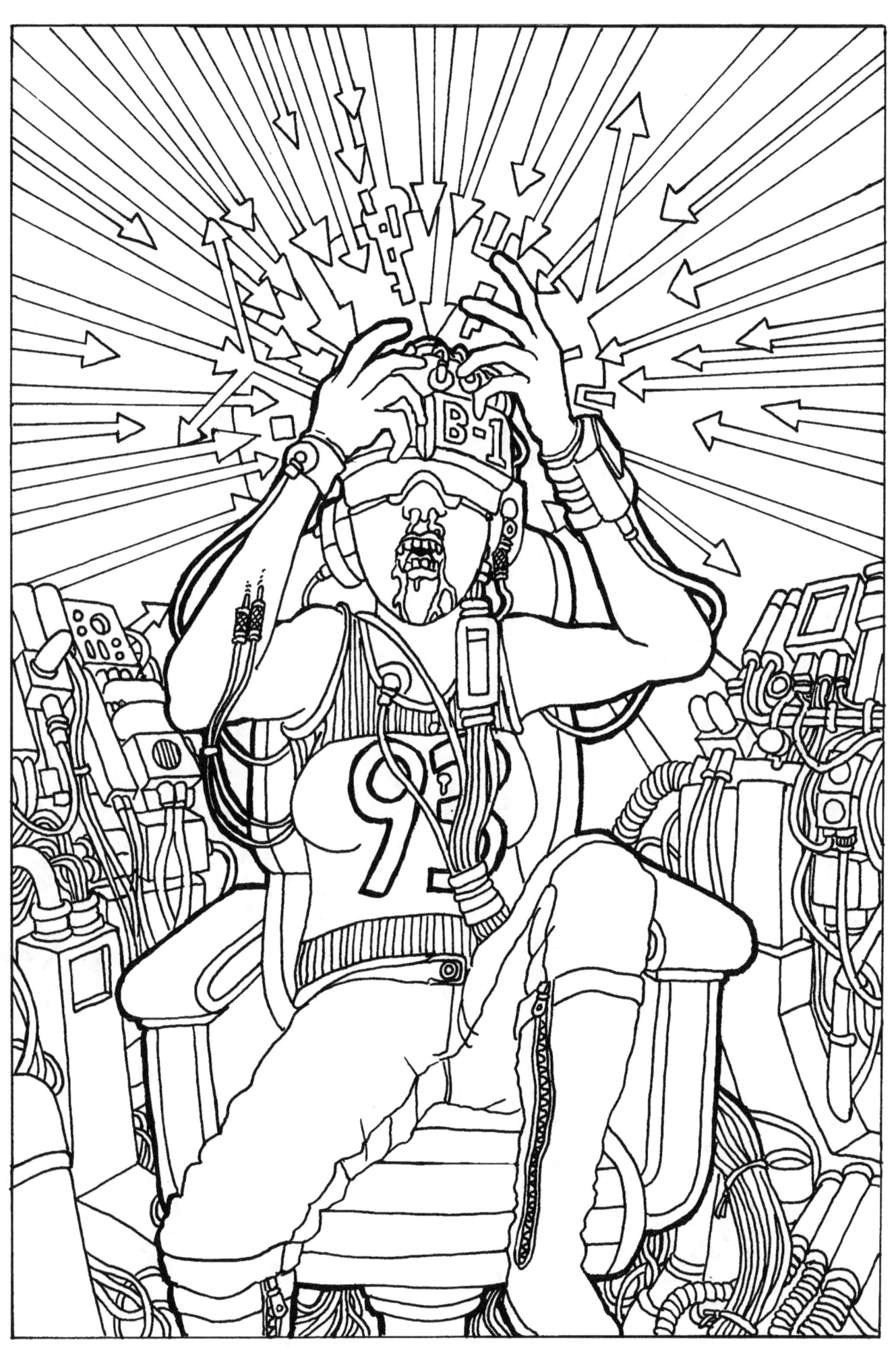

//16. BLACK ICE

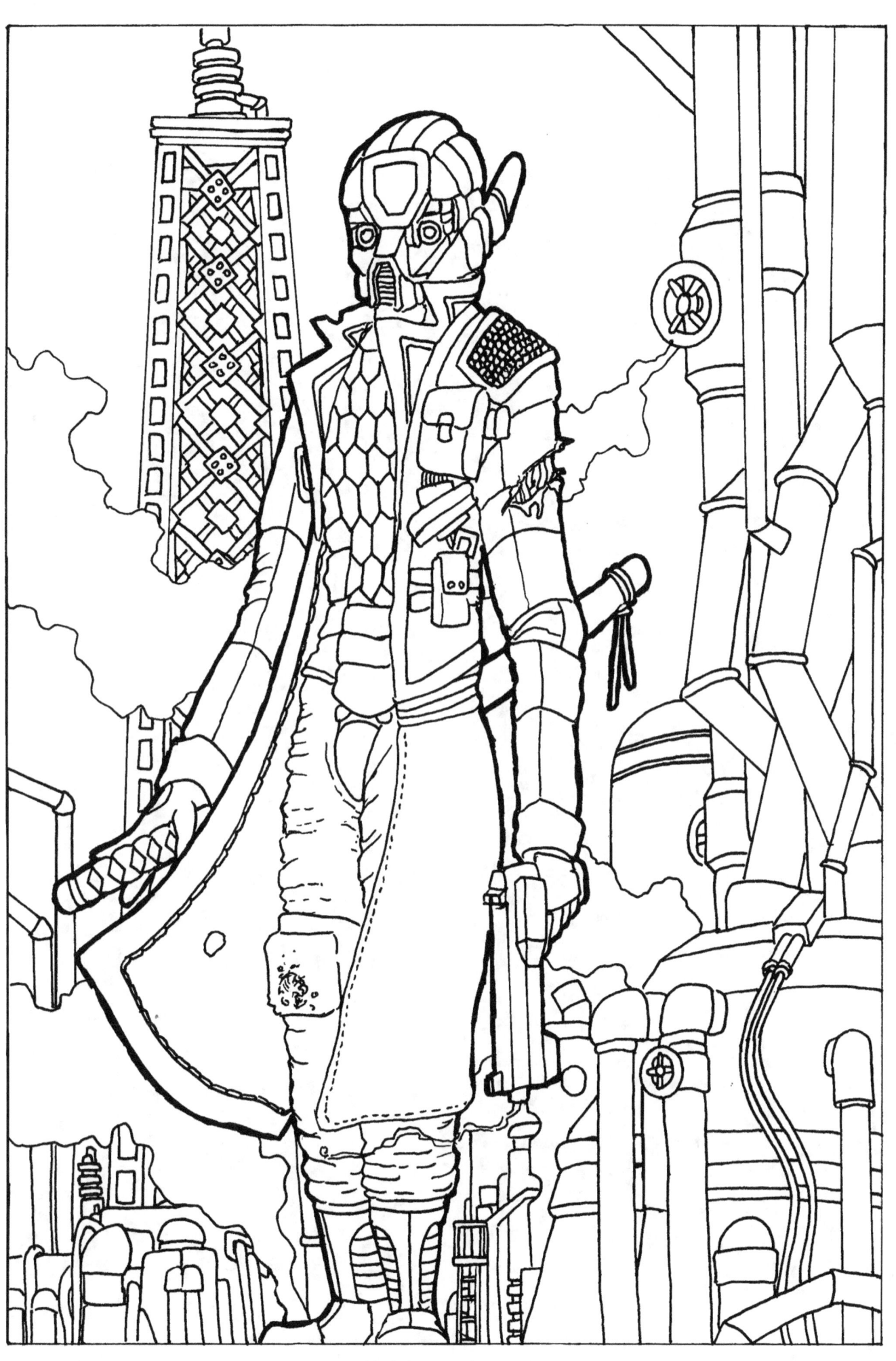

//17. STREET SAMURAI

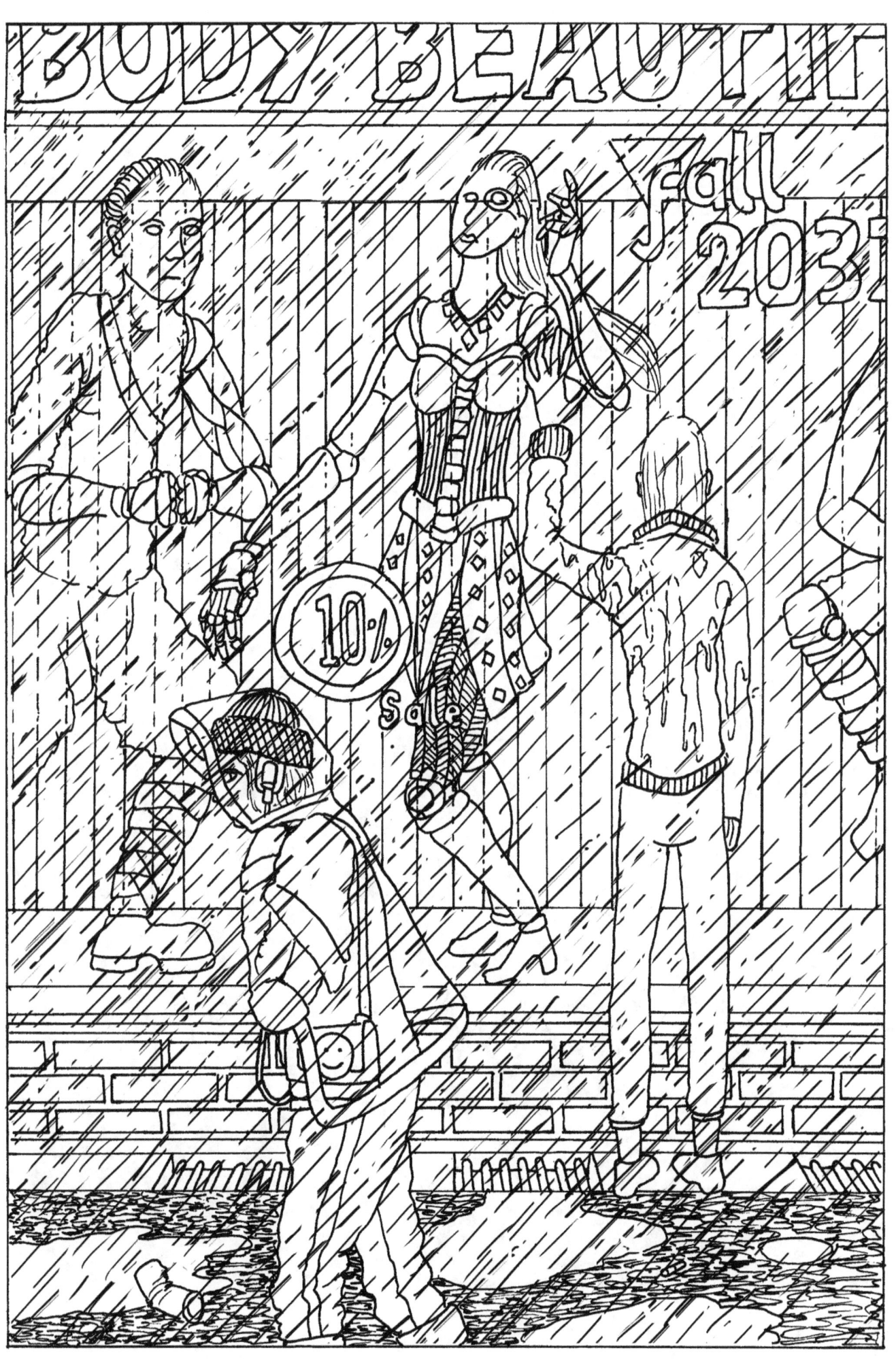

//18. ASPIRATION

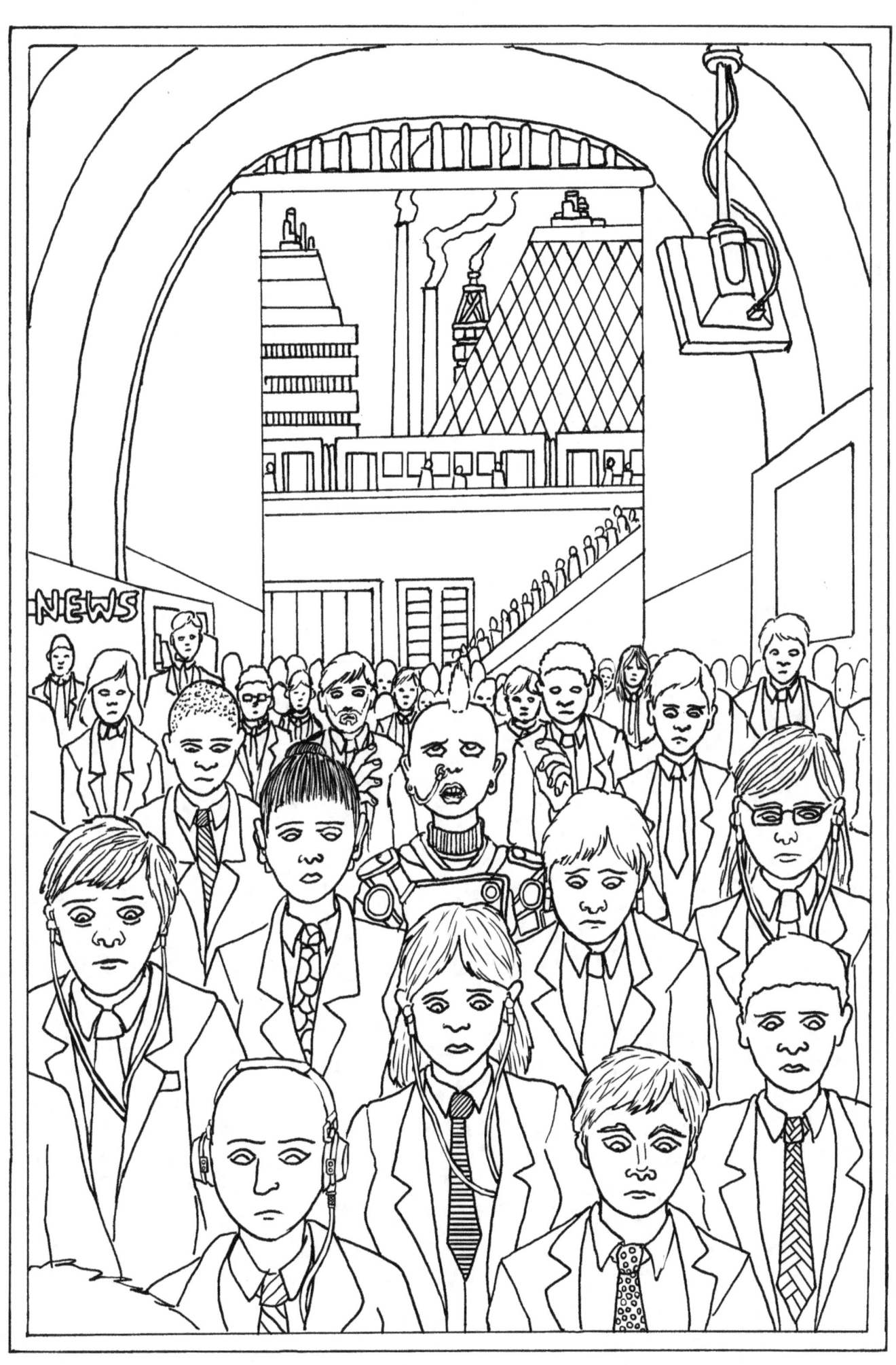

//19. THE SCREAM OF CULTURE

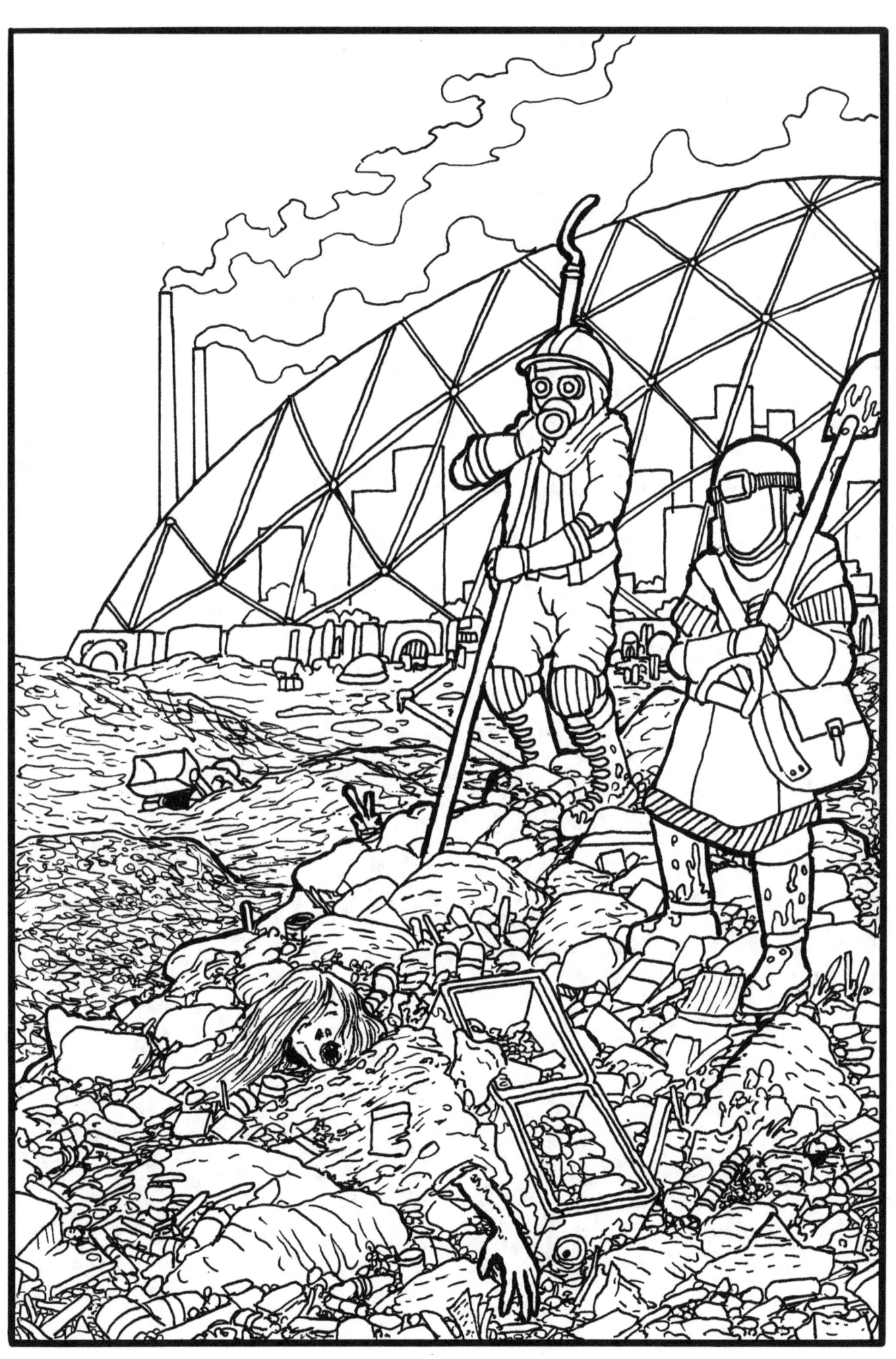

//20. DISCARDED

Other Titles from Idle Toil Press:

Available via lulu.com, amazon.com and other leading online booksellers.

By DS Blake:
Illustration and Cartoons

The Glimmercage Urists, or A Catalogue of Dwarven Calamities: A Dwarf Fortress book
ISBN: 9781291674828

Bowel Movements: Modern Art History on the Lavatory
ISBN: 9781326349653

The Occult Colouring Book
ISBN: 9781326505752

By Simon Cardew:
Artist's Books

Exonomnicon
ISBN: 9781291341720

Manifest-O
ISBN: 9781291341683

Vectis
ISBN: 9781291371314

Utopia/Dystopia
ISBN: 9781291536034

Speak of the Devil
ISBN: 9781291680300

16 Landscapes
ISBN: 9781291893854

Physical Remains
ISBN: 9781326252137

www.ingramcontent.com/pod-product-compliance
Lightning Source LLC
Chambersburg PA
CBHW081049170526
45158CB00006B/1906